COLOR
HARMONY

Jewels

GW00673375

ROCKPORT

First published in the United States
of America by
Rockport Publishers, Inc.
33 Commercial Street
Gloucester, Massachusetts 01930-5089
Telephone: (978) 282-9590
Facsimile: (978) 283-2742
www.rockpub.com

ISBN 1-56496-718-2

10 9 8 7 6 5 4 3 2 1

Design: Sara Day
Layout: SYP Design & Production
Cover Image: Francesco Jost

Printed in China

COLOR
HARMONY
Jewels

A GUIDEBOOK FOR CREATING GREAT COLOR COMBINATIONS

GLOUCESTER MASSACHUSETTS

ROCKPORT PUBLISHERS

Martha Gill

Contents

Introduction

Color is complicated. The multitude of color theories, systems, concepts, and definitions is mind boggling. The scientific aspects of color alone could fill volumes; from Isaac Newton's first circular diagram now known as the "traditional" color wheel to today's color conscious corporate culture which has long employed the services of professional colorists to predict best selling colors and color combinations. Predictions are constantly changing, though, so finding the latest "in" color at any given moment could take a lifetime. And if you are like most people, you have made more than one color blunder—perhaps even dozens of color mistakes. In order to be able to select an optimal color palette, it's critical to understand just a few basic color principles.

This book has been created to make color selection and picking palettes easy. So easy that color will become a vehicle for you to communicate whatever it is you want to say about yourself, your home, your crafts, your design project, or your product. Think of this book as a working tool with color swatches to use, palettes to review, and advice to consider. Here you will find the basic principles of color theory explained in an easy-to-understand format that focuses on mixing jewel color combinations. Also included are fourteen "moods" based on a jewel-colors palette, harmoniously matched with over 152 color combinations from energetic and invigorating to fresh and sunny palettes—all inspired by the wide array of today's modern jewel hues.

Varying Color Systems

Different color systems are used by artists, printers, and scientists. Artists and painters use three primary colors—red, yellow, and blue—to create all other colors (this is the system discussed in this book). However, this book is printed using the print industry's method of combining tiny dots of cyan, magenta, yellow and black to build specific colors through dot patterns that our eyes naturally "mix" and interpret as a wide array of colors. Scientists use an entirely different system based on light where red, green, and blue are used as the primaries. An example of this color system would be the colors generated on a computer screen monitor or television.

Jewels

Jewels are the most vivid, intense and fully saturated colors of the color wheel. Energetic and active, they make a statement wherever they are used. Attention grabbing jewels are sporty, exuberant, and can leave a viewer absolutely giddy. Sadly, many believe that bright colors should be relegated to the status of accent colors, used only to punctuate pastel or natural color palettes.

The early use of natural pigments and vegetable dyes resulted in palettes with a muted tone, and so jewels throughout the ages have been considered rare, sought after, and greatly desired. For example the use of bright yellow by European aristocrats as a vivid and important hue increased with the development in 1771 of a sunny lemon yellow called Turner's yellow. This spirited color became a hallmark of European-style "Georgian" interiors.

No longer the exclusive domain of the wealthy and affluent, today bright colors abound. Contemporary British designer Trisha Guild (a noted colorist, designer of fabric, wallpaper, and home furnishings) uses bright colors and patterns, liberally breaking the rules by using jewels at their fullest strength in small rooms, hallways, and tiny alcoves.

This book showcases the wide range of color choices and moods now available within a bright and vivid palette. From playful and exotic to regal, hypnotic and exuberantly modern, jewels have never been more saturated and pure than they are today. Forget the safe combinations of past neutral colors and enjoy the warmth and vibrancy that a gloriously bright palette embraces.

The Color Wheel

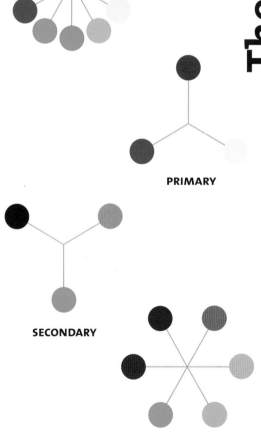

PRIMARY

SECONDARY

TERTIARY

The twelve segments of the traditional color wheel consist of primary, secondary, and tertiary hues and their specific tints and shades. With red at the top, the color wheel identifies the three primary hues of red, yellow, and blue. These three primary colors form an equilateral triangle within the circle. The three secondary hues of orange, violet, and green are located between each primary hue and form another triangle. Red-orange, yellow-orange, yellow-green, blue-green, blue-violet, and red-violet are the six tertiary hues. They result from the combination of a primary and secondary hue.

Constructed in an orderly progression, the color wheel enables the user to visualize the sequence of color balance and harmony.

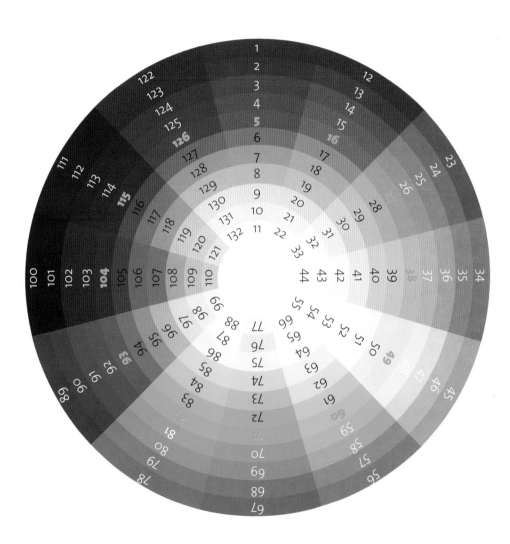

Jewel Color Chart

1	12	23	34	45	56	67
2	13	24	35	46	57	68
3	14	25	36	47	58	69
4	15	26	37	48	59	70
5	16	27	38	49	60	71
6	17	28	39	50	61	72
7	18	29	40	51	62	73
8	19	30	41	52	63	74
9	20	31	42	53	64	75
10	21	32	43	54	65	76
11	22	33	44	55	66	77

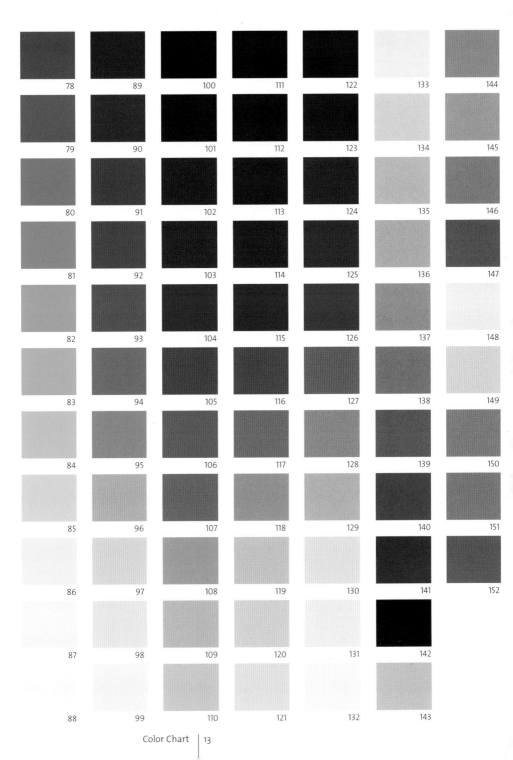

78 89 100 111 122 133 144
79 90 101 112 123 134 145
80 91 102 113 124 135 146
81 92 103 114 125 136 147
82 93 104 115 126 137 148
83 94 105 116 127 138 149
84 95 106 117 128 139 150
85 96 107 118 129 140 151
86 97 108 119 130 141 152
87 98 109 120 131 142
88 99 110 121 132 143

Jewels

The purest of colors, bright hues are full of energy. Color is energy, created by life giving light so it's no wonder that bright colors reflect the most energetic of emotions. Whether combining jewels with other bright hues or with pastels, naturals, metals or woods, understanding just a few of the basic color principles is the first step toward achieving exhilarating results.

Consider the color wheel, traditionally divided into two parts—a warm side and a cool side. The warm side of the color wheel features reds, oranges, and yellows and is considered active and exciting. The cool side spans from green to blue to the coolest violet hues and is considered passive and calming. Each side embodies a specific set of emotions. The primary colors in painting are red, yellow, and blue—the colors from which all other colors are created. Secondary colors are created when two primaries are mixed together, orange, green, and violet. Lastly the tertiary colors are red-orange, yellow-orange, yellow-green, blue-green, blue-violet, and red-violet. By understanding the structure of the color wheel you can begin to select colors that are natural in origin using one or more hues to

© 35mm/Photonica

create and mix successful color palettes within basic color schemes.

Jewels similar in hue can be used to create a simple "all-one-color" scheme known as monochromatic. Another very successful scheme for jewels is to select any three consecutive colors on the color wheel at their fullest saturation—for example, try blue, blue-green, and green. When paired together at the same value they will inevitably create a color sensation that's impossible not to notice. Combine any vivid hue with it's direct opposite on the color wheel for a basic color scheme that is called "complementary". Close your eyes and imagine a bright complementary color palette; envision eye popping reds

mixed with clean emerald greens or a vital chartreuse and magenta combo. Use the color to the immediate left or right of its complement on the color wheel to create a complex and sophisticated mix that is known as a tertiary color scheme. This type of innovative scheme could incorporate sunny yellows teamed with crisp blue violets and warm magenta tones.

Jubilant jewels mix well and add interest to just about any palette. Natural color schemes become more vibrant and lively with the strategic addition of bright hues. A basic terra cotta and cream scheme can become spicy and exotic with when mixed with chili pepper reds and an intense tangerine orange. Pastels will pop especially when a jewel is used of the same color—for example, a magenta pairs well with a pale pinky purple hue, or you can combine a vivid yellow-orange with a rich shade of butter cream. Mix jewels with metallics for a futuristic look or combine with various woods such as ruddy oak or pale pine to stabilize and ground. Jewels refresh, invigorate, and renew standard palettes, bringing life to old and new color combinations again and again. Jewels can be sassy, spicy, and outrageous. Rely on jewels to interject excitement, make a statement and above all to get attention.

Creating Your Own Palette

Professional graphic designers use tear out color swatches to select colors. Use the color swatches in this book combined with one of these systems, or if needed enhance with paint swatches from a paint or hardware store to develop your own personal palette.

Energetic (RED)

The most energetic color of the color wheel is red. Red at its most dramatic and classic is paired with black. Red and black, a timeless combination used by artists, graphic, package, and product designers worldwide when maximum visual impact is desired. A power color when used in graphics, red paired with black is the classic color for corporate identity. Ironically red is seldom used in the financial section of corporate annual reports due to the widely held superstition of "being in the red". Hard to ignore, red is best used sparingly as decorative accents in interiors such as overstuffed floor pillows, objects of art or a brilliant display of blooms.

© Wilhelm Scholz/Photonica

5

6 5

4 5

3 5

1 5

4 5 6

3 5 7

5 2 6

1 5 6

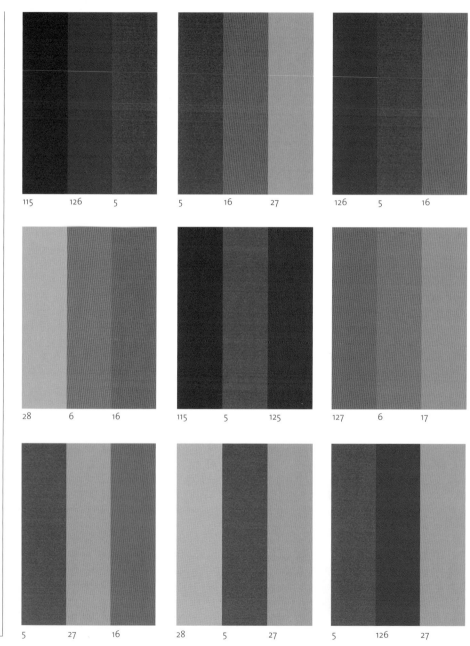

115 126 5

5 16 27

126 5 16

28 6 16

115 5 125

127 6 17

5 27 16

28 5 27

5 126 27

71 5 6 70 5 69

60 5 58 5 61 5

82 5 79 6 83 5

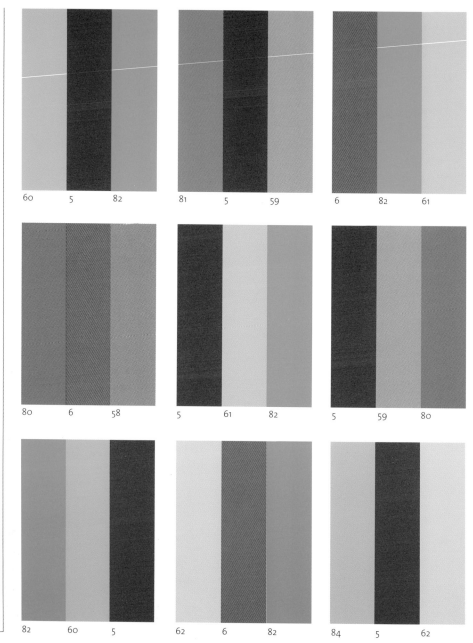

60 5 82

81 5 59

6 82 61

80 6 58

5 61 82

5 59 80

82 60 5

62 6 82

84 5 62

142 5 149 5 144 6

150 5 138 6 1 5

34 5 23 122 5 1 12 5 147

Sporty
(RED-ORANGE)

A zippy sporty color, red-orange is often used for active wear and action oriented products. From para-sails to surf boards, this tangerine hue is full of fun. Inventive combos that are lively and spirited team red-orange with aquamarine, emerald, magenta, and lemon yellow. Used at its brightest and fullest saturation, red-orange rivals red as a moving, high contrast color that's energy-packed.

© Minori Kawana/Photonica

16

17 16

15 16

14 16

21 16

15 16 17

14 16 18

16 12 15

18 16 17

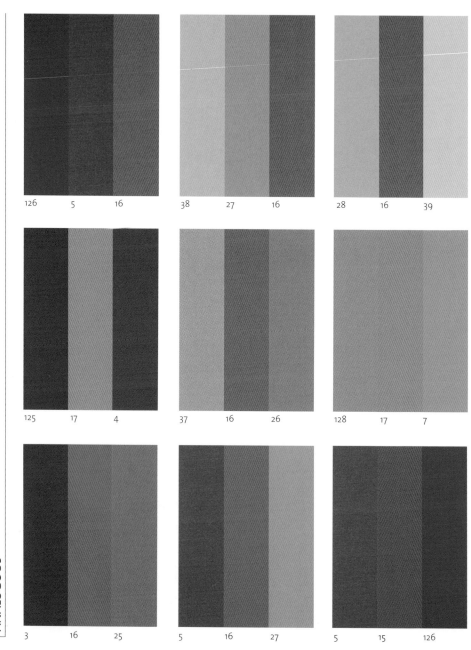

126 5 16 38 27 16 28 16 39

125 17 4 37 16 26 128 17 7

3 16 25 5 16 27 5 15 126

82 16

81 17

16 80

71 16

93 16

92 17

16 69

96 16

67 16

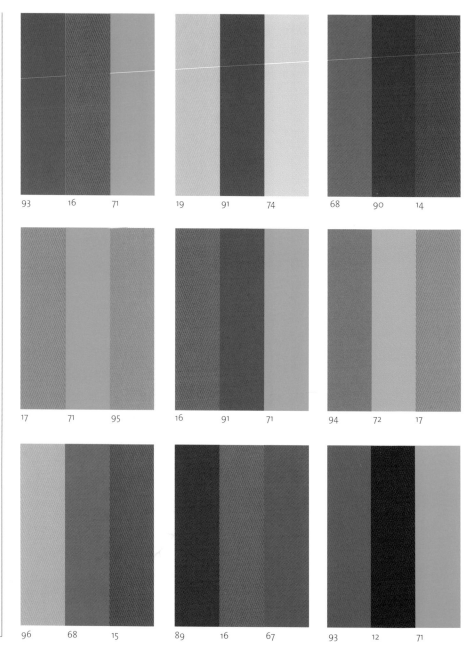

93 16 71 19 91 74 68 90 14

17 71 95 16 91 71 94 72 17

96 68 15 89 16 67 93 12 71

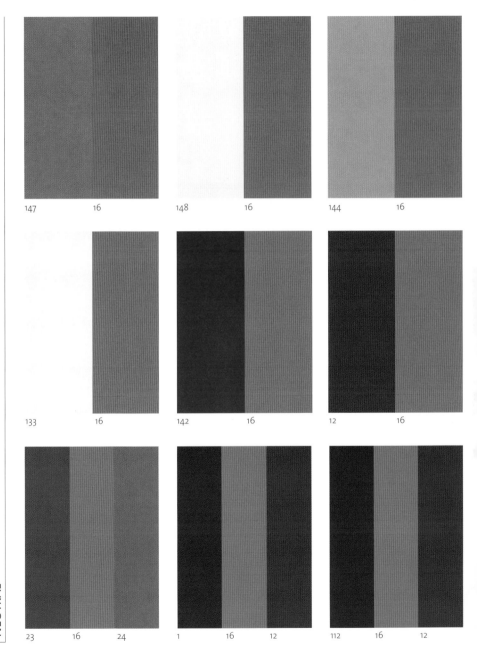

147 16 148 16 144 16

133 16 142 16 12 16

23 16 24 1 16 12 112 16 12

NEUTRAL

Exuberant (ORANGE)

Spirited, frolicsome and friendly, orange color combinations are dashing and radiant. An exuberant ride on a merry-go-round matches the mood of orange when used in full saturation. When deepened to a jewel tone, orange becomes a lavish and luxuriant color with a positively joyous aura. Use orange to generate feelings of festivity, generosity, and abundance. Heap oranges in a bowl for an instant flash of color. Select a floral pattern fabric with ocher-yellow and tawny tones for a welcoming guest room. Because orange is a highly visible color that is both bold and appealing, it is often used by costume and set designers who seek theatrical flair.

© Erik Rank/Photonica

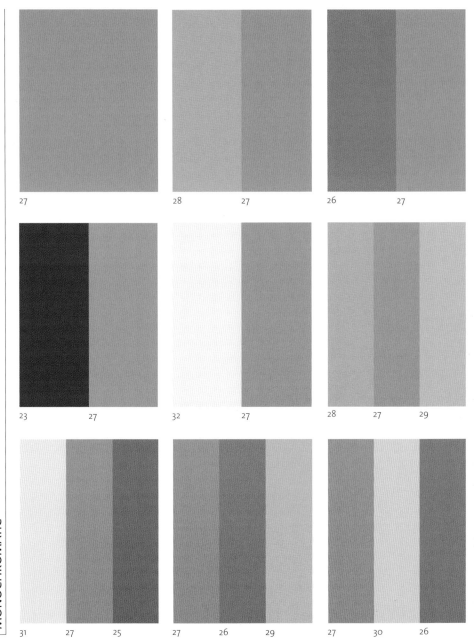

27

28 27

26 27

23 27

32 27

28 27 29

31 27 25

27 26 29

27 30 26

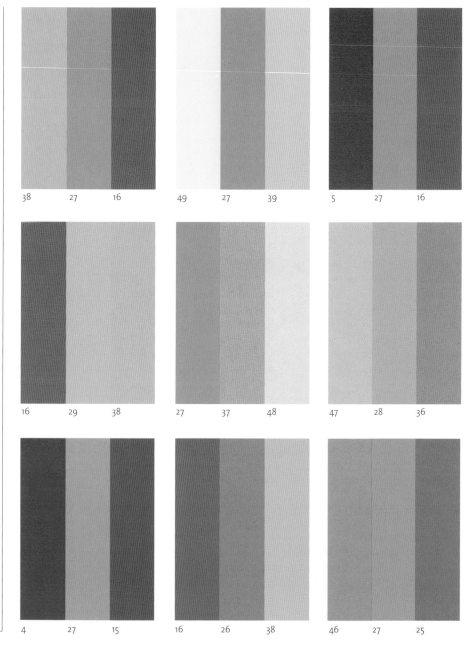

38 27 16 49 27 39 5 27 16

16 29 38 27 37 48 47 28 36

4 27 15 16 26 38 46 27 25

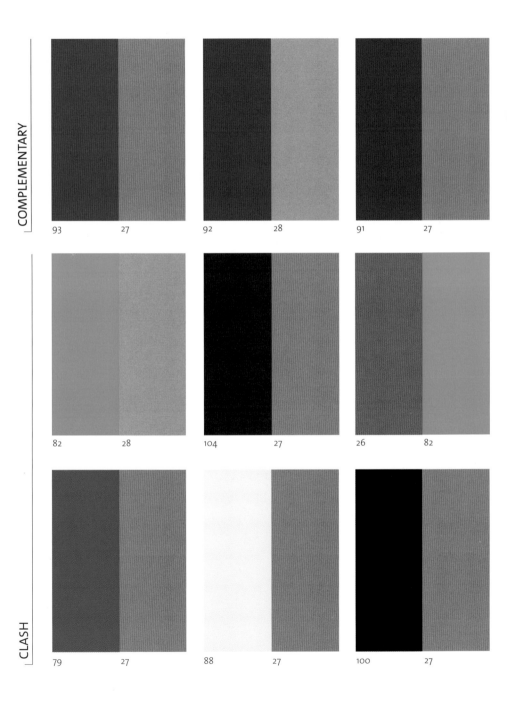

93 27 92 28 91 27

82 28 104 27 26 82

79 27 88 27 100 27

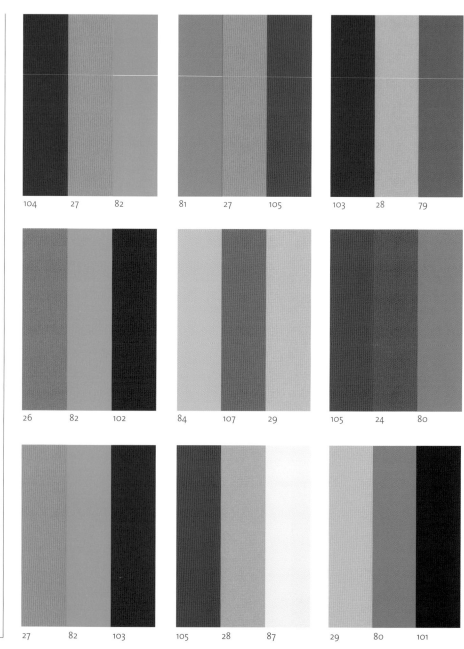

104 27 82

81 27 105

103 28 79

26 82 102

84 107 29

105 24 80

27 82 103

105 28 87

29 80 101

134 27 149 28 143 27

147 28 142 27 23 27

12 27 23 34 28 149 44 27 34

NEUTRAL

(YELLOW-ORANGE) Active

Very bright color combinations feature yellow and orange. Both are at the center of this color wheel hue that generates activity and motion. Yellow blended with orange is alive and dynamic, adding energy and vitality to any color scheme. Few color combinations are as compelling as yellow-orange when combined with its complement, blue-violet. To make an immediate and lasting impression on the eye use this dynamic color that ebbs, flows and always moves. Combine this golden yellow with sky blue, turquoise, or chartreuse in full saturation for bright and striking combinations.

© Masakatsu Yamazaki/Photonica

38

39 38

40 38

41 38

37 38

36 38 37

39 38 40

35 38 37

41 38 37

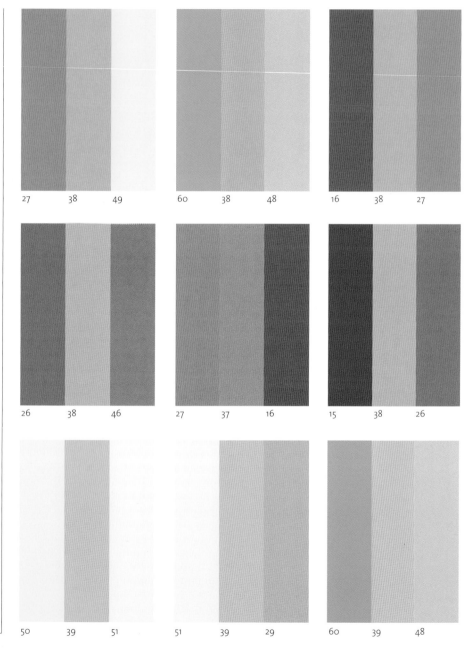

27 38 49

60 38 48

16 38 27

26 38 46

27 37 16

15 38 26

50 39 51

51 39 29

60 39 48

104 38 105 39 103 38

115 38 93 38 90 39

113 38 121 38 91 39

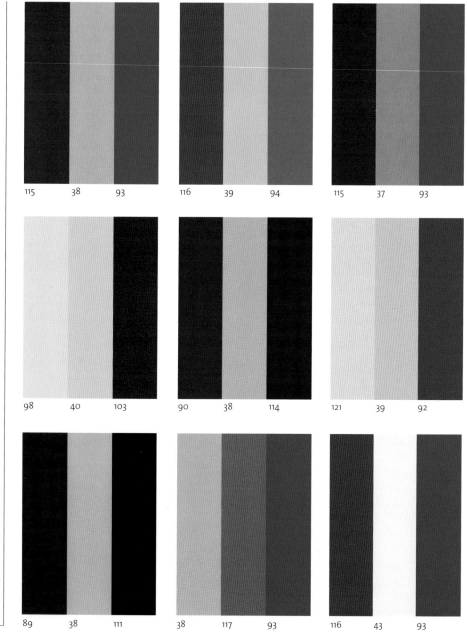

115 38 93

116 39 94

115 37 93

98 40 103

90 38 114

121 39 92

89 38 111

38 117 93

116 43 93

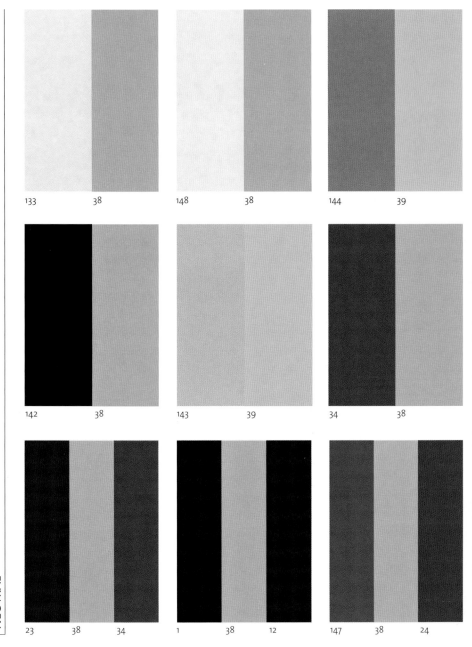

133 38 148 38 144 39

142 38 143 39 34 38

23 38 34 1 38 12 147 38 24

NEUTRAL

Modern (YELLOW)

Chrome yellow was first manufactured at the beginning of the nineteenth century making it, by planetary standards, a very modern color. A fast favorite with the imperial crowd, it was considered a regal color in the western world and a holy color in the East where it is associated with the life giving sun. Today yellow and its many variations are sometimes used to indicate the arrival of spring. Instead of diminishing its cheery confidence, adding white to yellow enhances its brightness and luminescence.

© The Special Photographers Co./Photonica

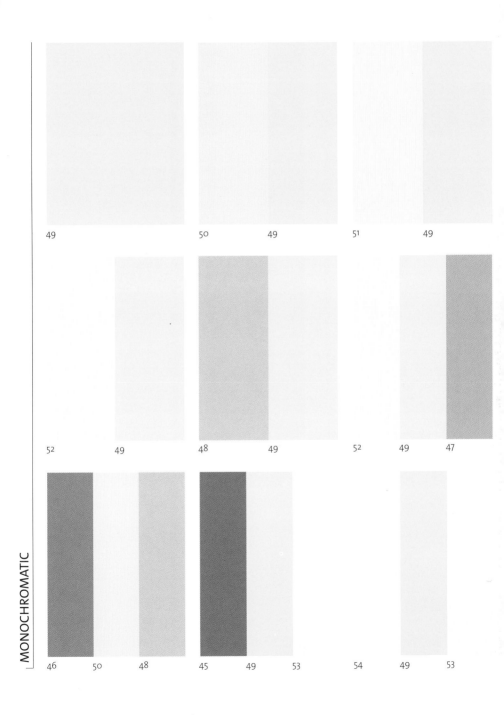

49

50 49

51 49

52 49

48 49

52 49 47

46 50 48

45 49 53

54 49 53

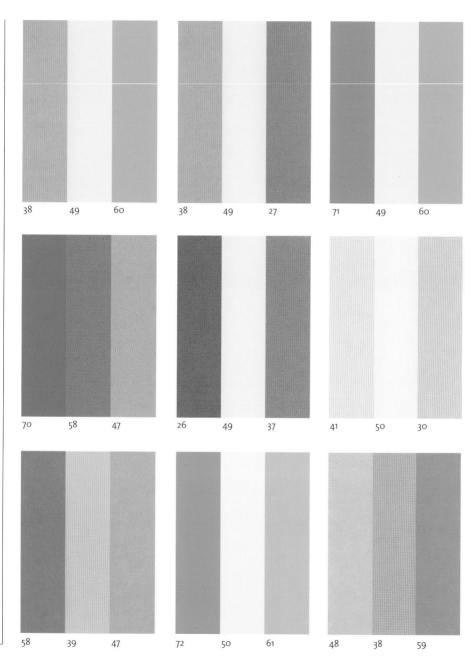

38 49 60

38 49 27

71 49 60

70 58 47

26 49 37

41 50 30

58 39 47

72 50 61

48 38 59

| 115 | 59 | | 116 | 48 | | 114 | 50 |

| 126 | 49 | | 104 | 49 | | 125 | 50 |

| 105 | 48 | | 124 | 47 | | 127 | 51 |

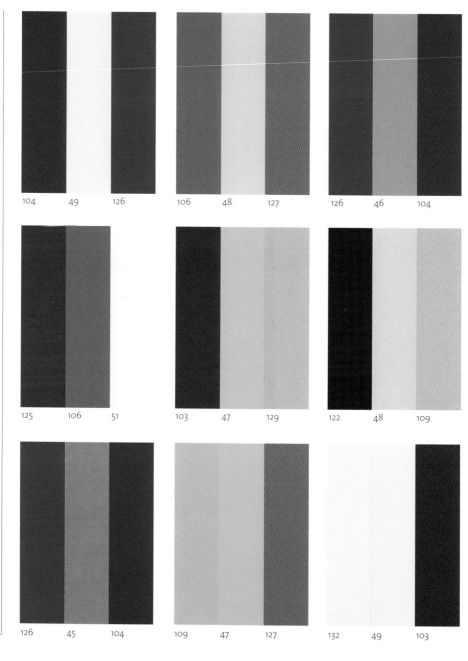

| 104 | 49 | 126 | | 106 | 48 | 127 | | 126 | 46 | 104 |

| 125 | 106 | 51 | | 103 | 47 | 129 | | 122 | 48 | 109 |

| 126 | 45 | 104 | | 109 | 47 | 127 | | 132 | 49 | 103 |

133 49 141 50 147 48

143 51 142 49 45 50

34 50 23 1 49 12 35 47 25

Invigorating (YELLOW-GREEN)

When the two primaries, blue and yellow, are combined with an extra dash of yellow the result is a yellow-green sensation that is bright, energizing, and invigorating. Shake up this hue with its complement, red-violet, for a mix thatís full of energy and stimulation. Crisp, cool, and exhilarating, this youthful color is often used for trendy products, adolescent and juvenile fashions. Bring the bright intensity of summer sunshine to a breakfast nook and pull together fully saturated citrus shades such as lime, lemon, and orange.

© Howard Bjornson/Photonica

60

61 60

62 60

63 60

58 60

61 60 56

57 60 56

65

61 62

58 60 59

MONOCHROMATIC

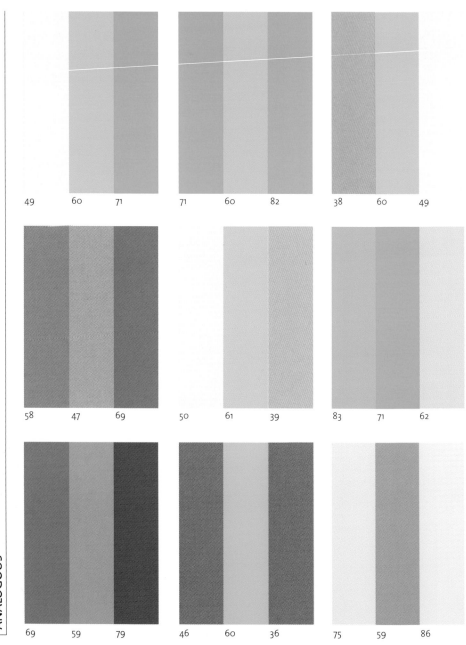

49 60 71 71 60 82 38 60 49

58 47 69 50 61 39 83 71 62

69 59 79 46 60 36 75 59 86

ANALOGOUS

126 60 58 127 125 61

5 60 115 61 4 64

121 58 63 4 57 115

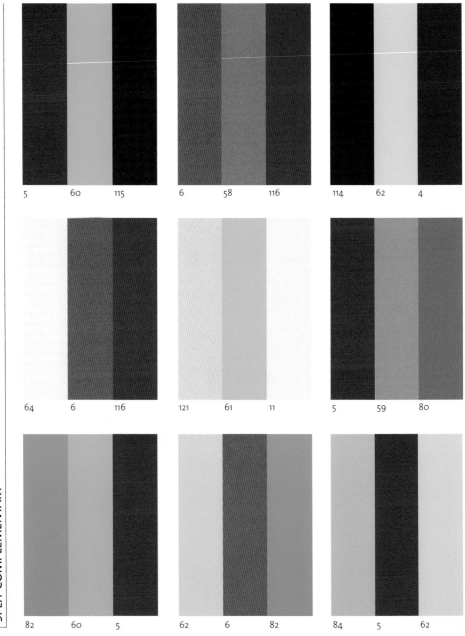

5	60	115
6	58	116
114	62	4

64	6	116
121	61	11
5	59	80

82	60	5
62	6	82
84	5	62

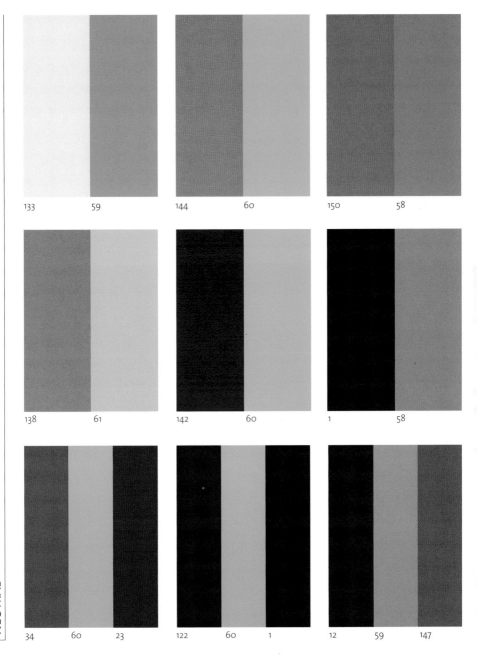

133 59

144 60

150 58

138 61

142 60

1 58

34 60 23

122 60 1

12 59 147

(GREEN + YELLOW-GREEN + YELLOW) Sunny

© Ron Routar/Photonica

Consider an analogous color scheme and use three consecutive hues or any of their tints and shades on the color wheel. This yellow, yellow-green and green combination brings a summery disposition wherever it is used. Sunny yellow adds clarity and brightness and green contains just the right amount of cool tones for balance and harmony. This trio can be used with confidence to freshen and invigorate. A favorite mix for children's rooms, this friendly blend will always energize its environment. Experiment with this basic scheme by adding touches of violet, red-violet, and red or simply expand the palette to include orange or blue tones.

49 60 57 46 45 62

50 59 63 52 55 60

45 61 56 51 52 63

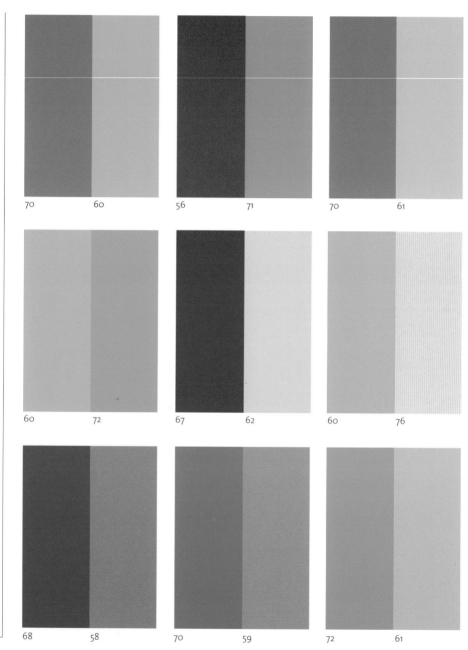

70 60 56 71 70 61

60 72 67 62 60 76

68 58 70 59 72 61

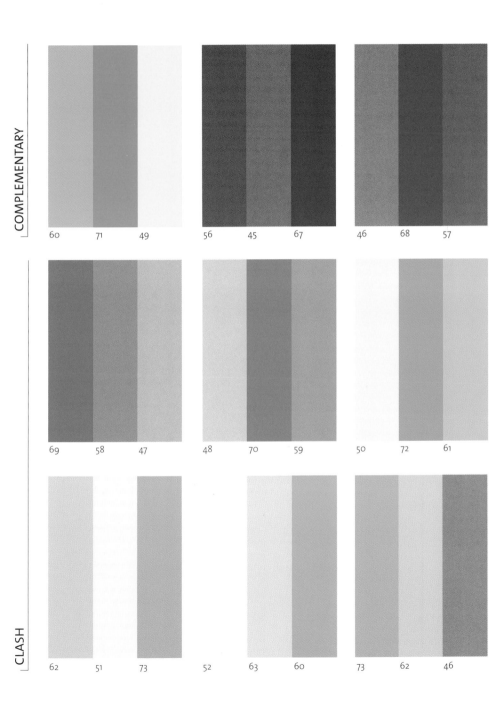

60 71 49 56 45 67 46 68 57

69 58 47 48 70 59 50 72 61

62 51 73 52 63 60 73 62 46

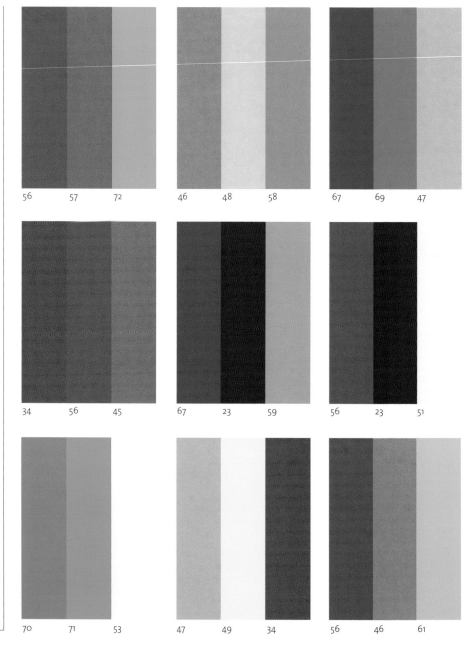

56 57 72 46 48 58 67 69 47

34 56 45 67 23 59 56 23 51

70 71 53 47 49 34 56 46 61

133 51 62 135 72 73 57 58 139

47 48 142 148 57 56 71 72 147

60 142 148 49 142 133 71 144 142

NEUTRAL

Fresh (GREEN)

Green when used in its brightest saturation is often referred to as grass green. A multitude of bright grassy greens harmonizes effortlessly in nature beautifully teamed with woodsy browns and sky blues. Create a simple "floral" arrangement by gathering the first fresh budding greenery of spring and bring the newness of this season indoors. Symbolic of health, wealth, and prosperity, green has cooling, soothing properties even when used at full strength. Intensify green with accents of red, coral and flame orange.

© Marco Monti/Photonica

71

72 71

73 71

74 71

70 71

69 71 70

68 71 74

75 72 73

67 71 68

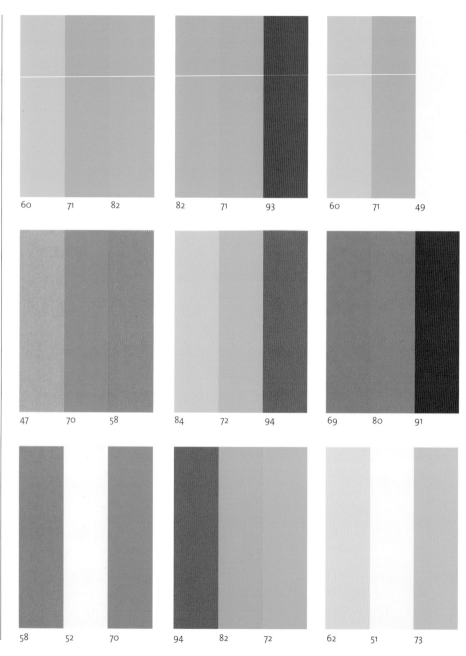

60 71 82 82 71 93 60 71 49

47 70 58 84 72 94 69 80 91

58 52 70 94 82 72 62 51 73

COMPLEMENTARY

6 71 72 5 4 71

126 71 16 70 125 72

CLASH

15 71 127 72 124 71

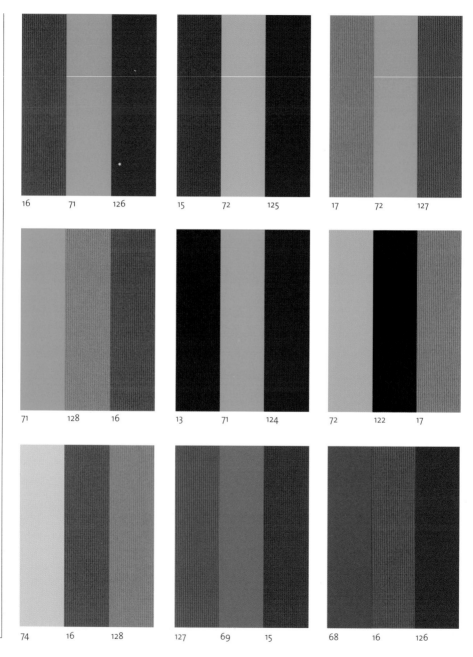

16 71 126 15 72 125 17 72 127

71 128 16 13 71 124 72 122 17

74 16 128 127 69 15 68 16 126

SPLIT COMPLEMENTARY

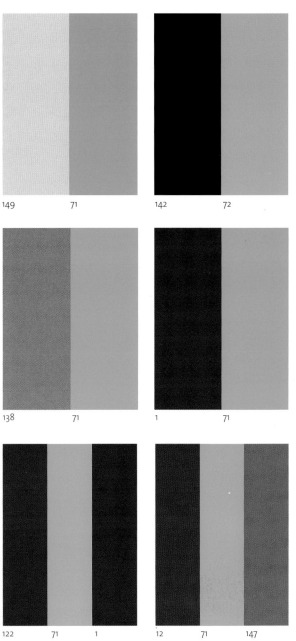

133 70

149 71

142 72

150 69

138 71

1 71

100 72 111

122 71 1

12 71 147

Luminous
(BLUE-GREEN)

The luminous colors of the sea, from deep blue to teal to emerald green, shine and dazzle with the brilliance of a passing tropical school of fish. Color selection is often influenced by place and culture, and sunny locations by the sea are renown for their use of bright colors. The essence of the sea and the sky can be seen in many an island's luminous sun-splashed palette. Island natives often instinctively blend brilliant greens and blues to create what are known as the tropical colors. These regionally inspired colors are handed down and honed through the gener-ations. To inspire the carefree mood of everyday island life simply use blue-green at its fullest saturation.

© The Picture Book/Photonica

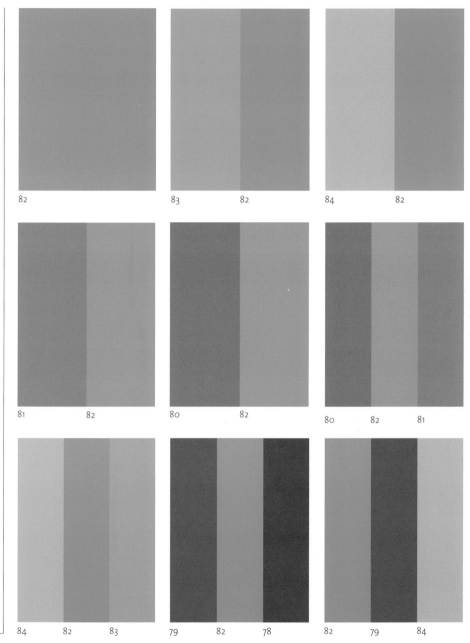

MONOCHROMATIC

82

83 82

84 82

81 82

80 82

80 82 81

84 82 83

79 82 78

82 79 84

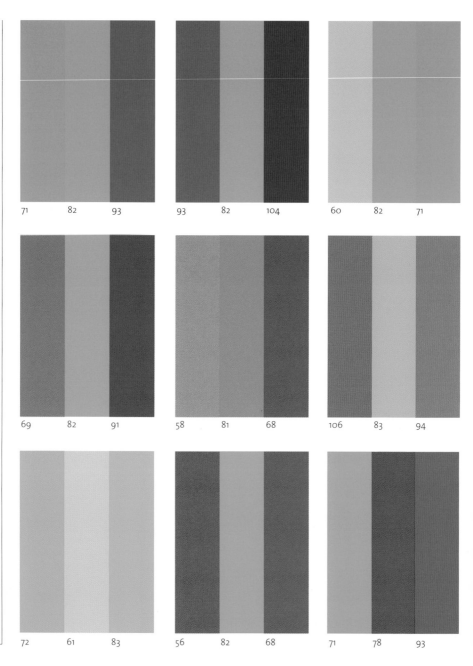

71 82 93 93 82 104 60 82 71

69 82 91 58 81 68 106 83 94

72 61 83 56 82 68 71 78 93

| 16 | 82 | 80 | 17 | 15 | 81 |

| 27 | 82 | 5 | 82 | 28 | 81 |

| 4 | 80 | 26 | 82 | 5 | 79 |

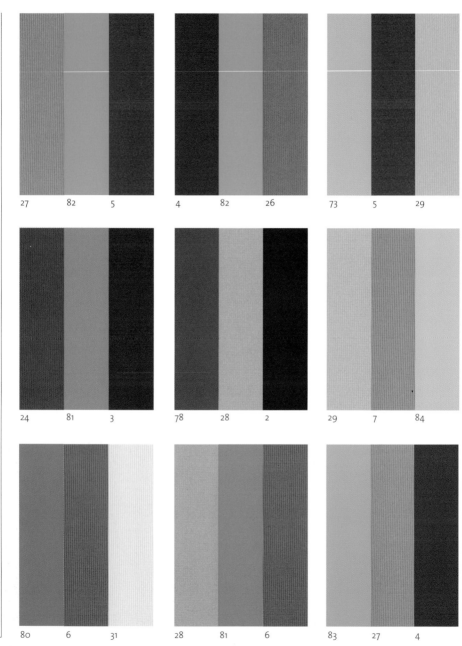

27 82 5 4 82 26 73 5 29

24 81 3 78 28 2 29 7 84

80 6 31 28 81 6 83 27 4

SPLIT COMPLEMENTARY

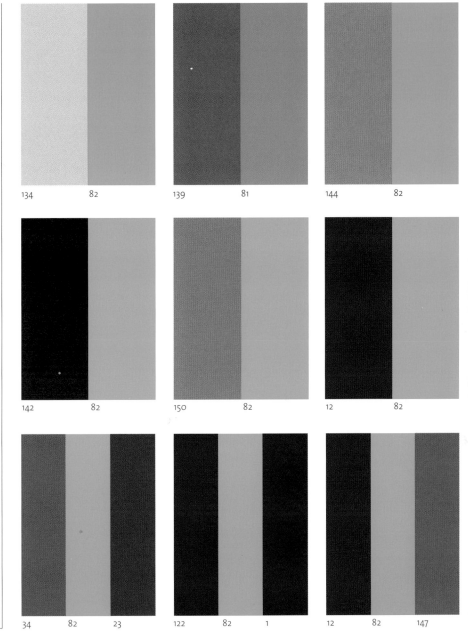

134 82

139 81

144 82

142 82

150 82

12 82

34 82 23

122 82 1

12 82 147

Hypnotic

Blue is one of the strongest jewels (second only to red) with pleasing hypnotic qualities when combined with its color-wheel neighbors, blue-violet and blue-green. Pleasant patterns for fabrics in checks, plaids, and Madras often use blue as a base color. The color for sea and air, blue is the anchor of many landscape paintings. Experiment with different shades and textures then heighten blue's intensity with emerald, aquamarine, lime, and citron hues.

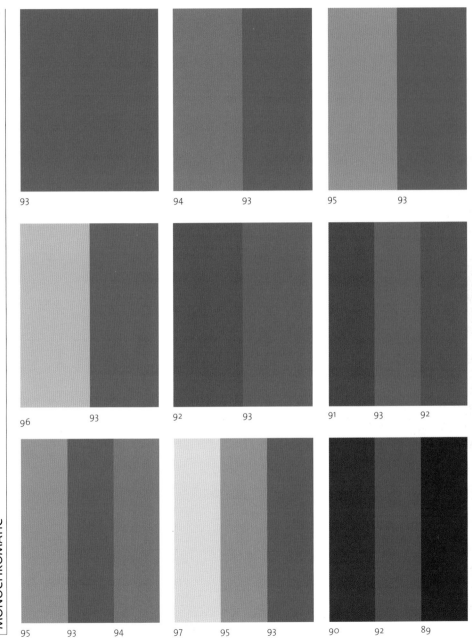

93

94 93

95 93

96 93

92 93

91 93 92

95 93 94

97 95 93

90 92 89

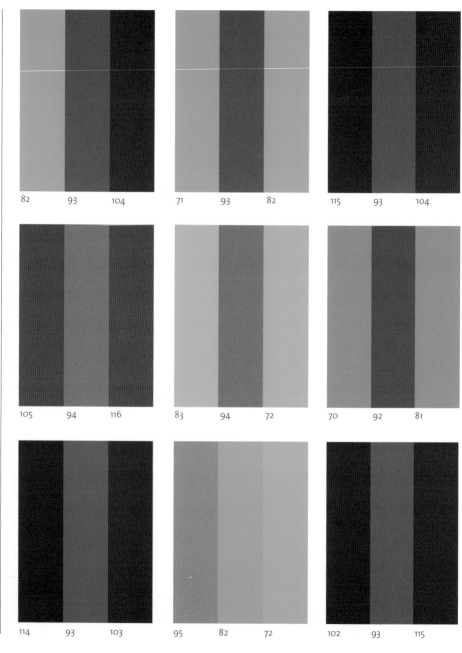

82 93 104

71 93 82

115 93 104

105 94 116

83 94 72

70 92 81

114 93 103

95 82 72

102 93 115

27 93

28 92

93 26

38 93

16 93

39 92

15 93

37 94

40 93

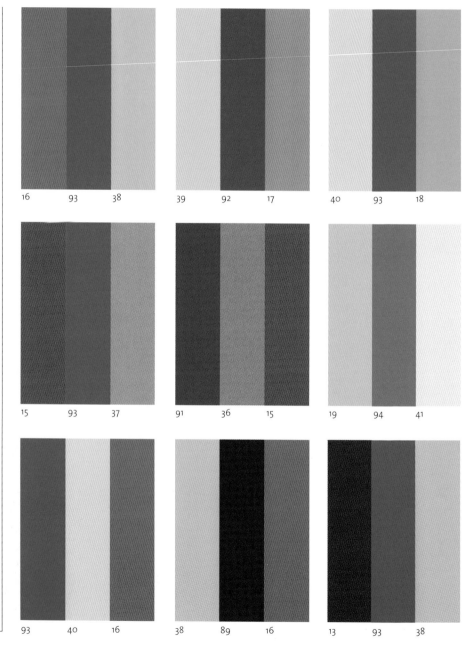

16 93 38 39 92 17 40 93 18

15 93 37 91 36 15 19 94 41

93 40 16 38 89 16 13 93 38

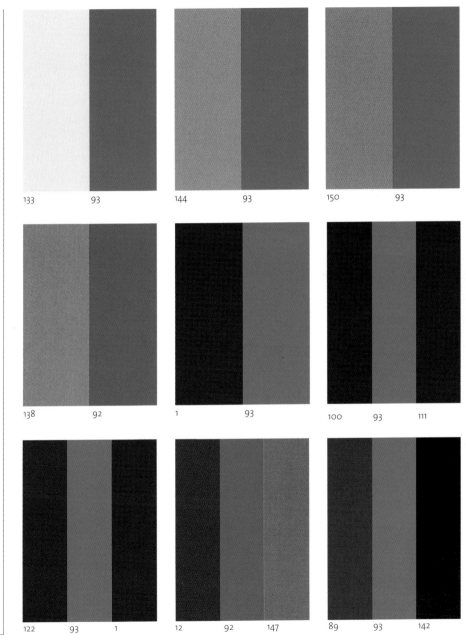

133 93 144 93 150 93

138 92 1 93 100 93 111

122 93 1 12 92 147 89 93 142

Regal
(BLUE-VIOLET)

Calm and collected, blue-violet leans a bit to the cooler side of "true" color wheel violet, ingratiating this hue with a stately presence. A color historically employed by European aristocrats, this "royal purple" carries itself with a majestic air. The intense phosphorescent qualities of this hue at full saturation have been known to fill one with longing—just envision paintings from Picasso's blue period or one of Van Gogh's swirling night skies. Enliven this blue-blooded violet with its cheery complement yellow-orange and plenty of gilded gold.

© Toshiaki Shimizu/Photonica

104

105 104

106 104

107 104

103 104

102 104 103

106 104 105

109 104 110

105 104 103

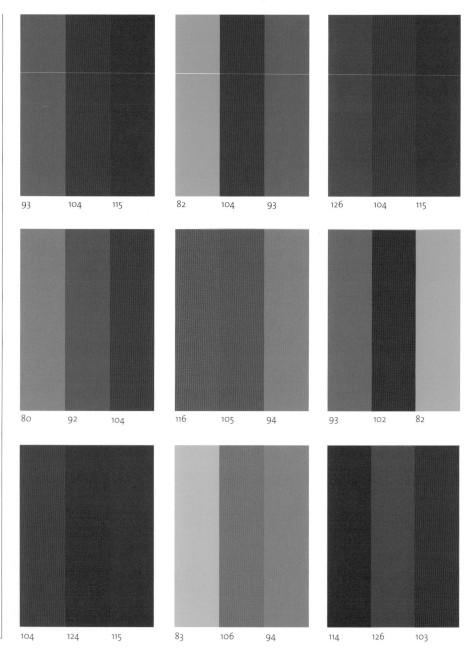

93 104 115

82 104 93

126 104 115

80 92 104

116 105 94

93 102 82

104 124 115

83 106 94

114 126 103

ANALOGOUS

38	104	
104	39	
40	105	

49	104	
27	104	
28	104	

51	106	
47	104	
26	105	

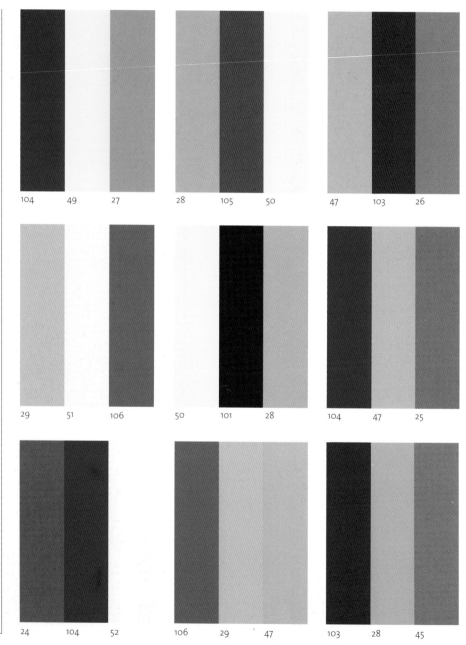

104 49 27

28 105 50

47 103 26

29 51 106

50 101 28

104 47 25

24 104 52

106 29 47

103 28 45

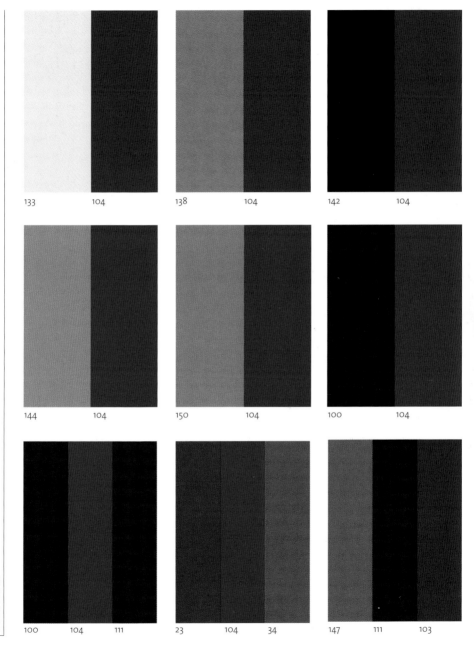

133 104 138 104 142 104

144 104 150 104 100 104

100 104 111 23 104 34 147 111 103

Exotic
(VIOLET)

A magical brightness permeates violet at its fullest saturation. Exotic, enchanting and vivid, violet is an unforgettable hue. Associated with the fashion and beauty industry, violet epitomizes femininity, beauty, and mystery. An emotional color, this purple hue can be deepened to a pleasant plum or softened to a rosy mauve. Shades of theatrical violet escalate with passion when combined with a palette of full robust blues and deep rosy reds, a compelling choice for modern interiors. Accent with chartreuse or buttercup yellow for a young, carefree mood.

© Minori Kawana/Photonica

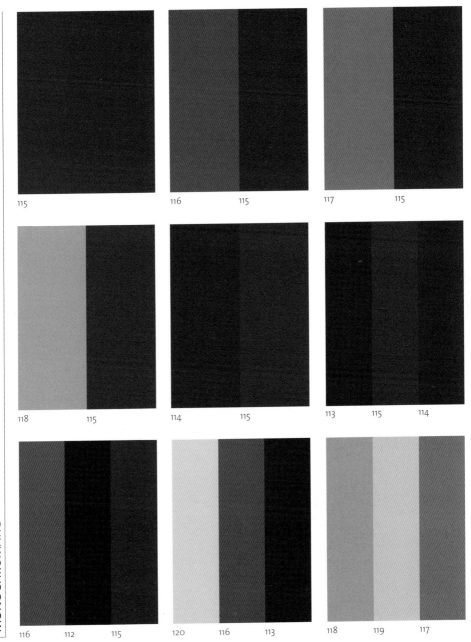

115

116 115

117 115

118 115

114 115

113 115 114

116 112 115

120 116 113

118 119 117

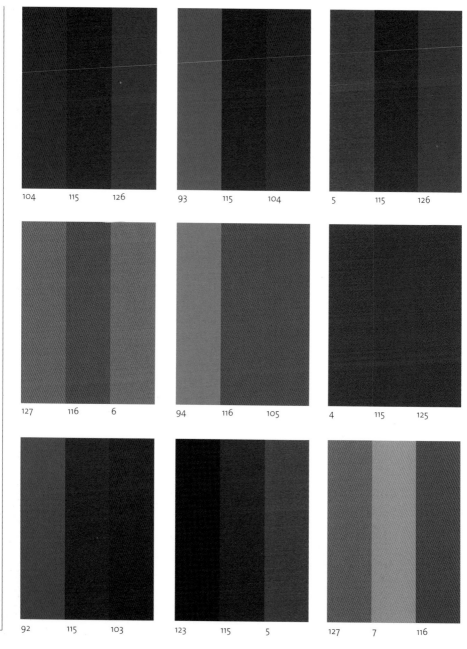

104 115 126 93 115 104 5 115 126

127 116 6 94 116 105 4 115 125

92 115 103 123 115 5 127 7 116

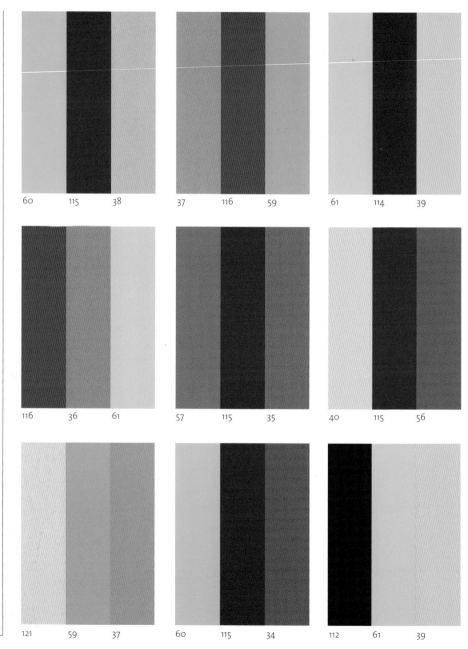

60 115 38 37 116 59 61 114 39

116 36 61 57 115 35 40 115 56

121 59 37 60 115 34 112 61 39

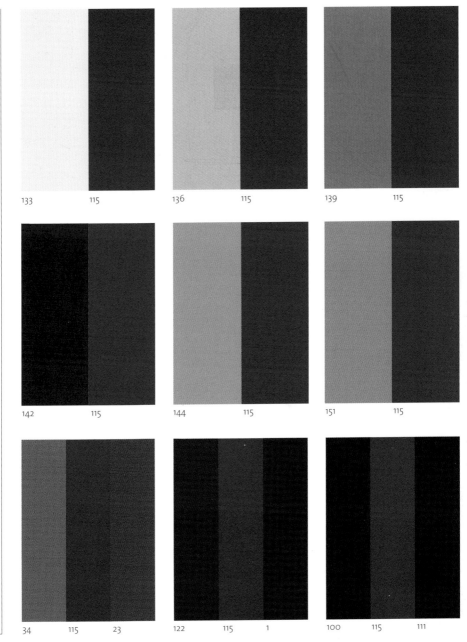

133 115 136 115 139 115

142 115 144 115 151 115

34 115 23 122 115 1 100 115 111

Imagine a color palette that is as rousing as unleashing a barrel of monkeys. Combine red-violet and yellow-orange to create an unconventional and bright arrangement that mixes two colors from the warm side of the color wheel. Give this upbeat and light-hearted pair added depth and contrast by using a black background, evoking hand-woven fabrics and crafts from Guatemala. Brighten further with a dash of a third tertiary color such as blue-green, or increase the level of warmth by blending with a bit of red-orange. Use these contrasting sub tropical colors to add movement and cheer to small spaces or to enliven an artist's canvas.

© Wayne Calabrese/Photonica

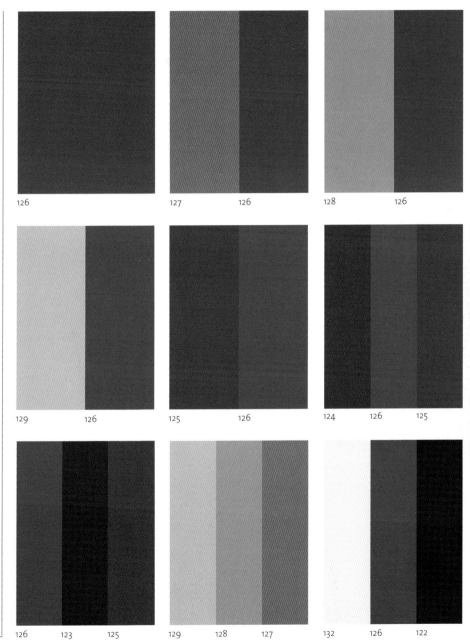

126

127 126

128 126

129 126

125 126

124 126 125

126 123 125

129 128 127

132 126 122

Playful (red-violet + yellow-orange) | 91

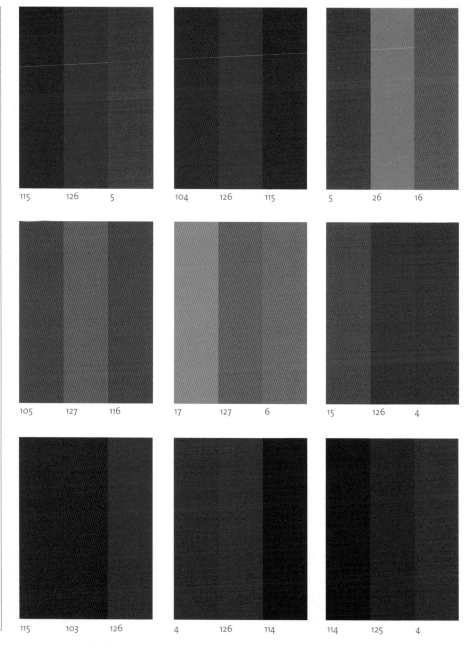

| 115 | 126 | 5 | | 104 | 126 | 115 | | 5 | 26 | 16 |

| 105 | 127 | 116 | | 17 | 127 | 6 | | 15 | 126 | 4 |

| 115 | 103 | 126 | | 4 | 126 | 114 | | 114 | 125 | 4 |

60 126 125 61 58 126

47 126 71 126 49 126

45 125 67 126 52 126

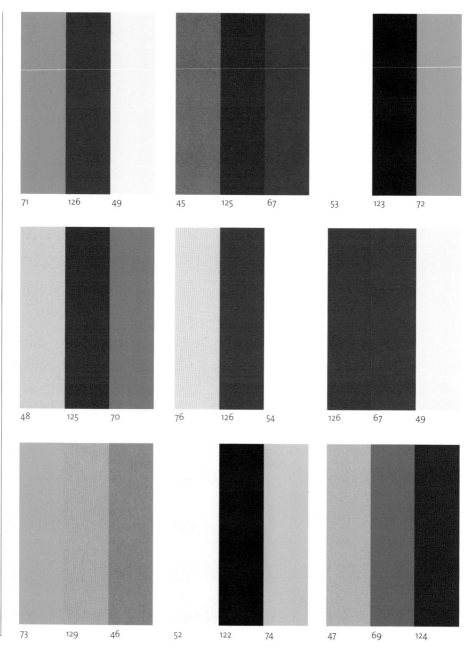

71 126 49

45 125 67

53 123 72

48 125 70

76 126 54

126 67 49

73 129 46

52 122 74

47 69 124

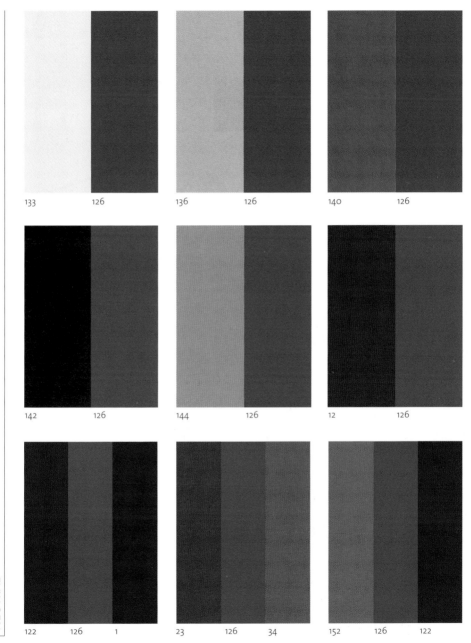

Vibrant

(RED + GREEN)

Vivid color combinations can be created by combining colors with their opposite on the color wheel. Traditionally red is positioned at the top of the color wheel and green, its direct opposite, is stationed at the bottom. Take it to the extreme and pair the hottest with the coolest for a vital and intense palette. Often written off as a seasonal holiday combo, red and green burst with energy throughout the year. Do not be afraid to cut loose and use these power-house complementary colors in full saturation or in tints and shades for a more sophisticated tone.

© Taro Kumamoto

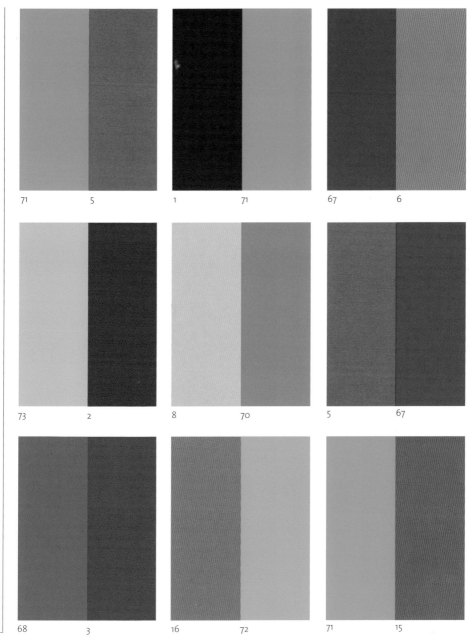

71 5 1 71 67 6

73 2 8 70 5 67

68 3 16 72 71 15

MONOCHROMATIC

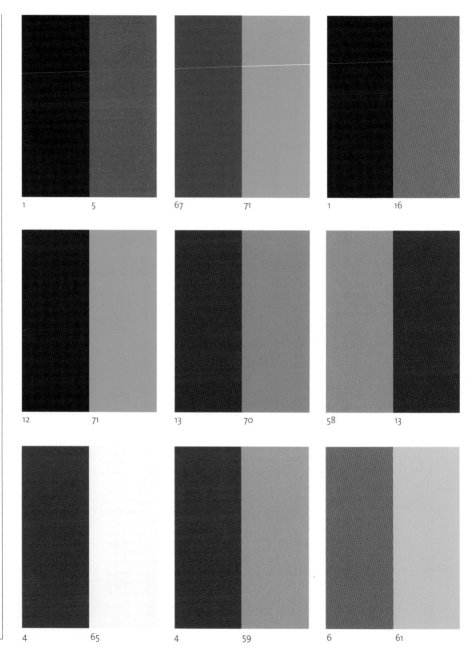

1 5 67 71 1 16

12 71 13 70 58 13

4 65 4 59 6 61

1	12	58

67	4	5

77	13	12

56	67	16

22	58	57

3	4	63

17	5	60

72	7	18

57	69	6

Vibrant (red + green) | 99

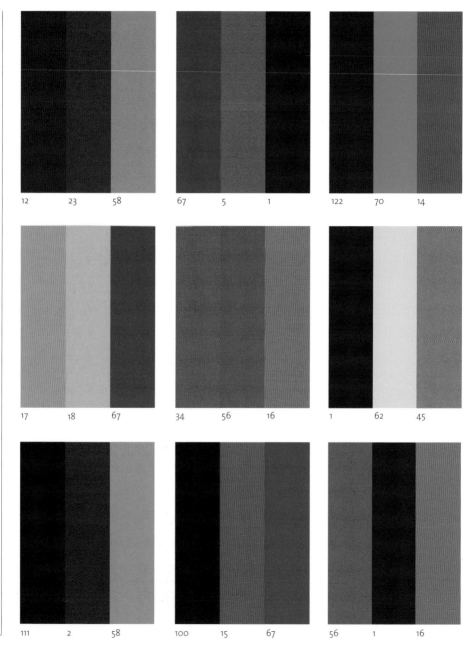

| 12 | 23 | 58 |

| 67 | 5 | 1 |

| 122 | 70 | 14 |

| 17 | 18 | 67 |

| 34 | 56 | 16 |

| 1 | 62 | 45 |

| 111 | 2 | 58 |

| 100 | 15 | 67 |

| 56 | 1 | 16 |

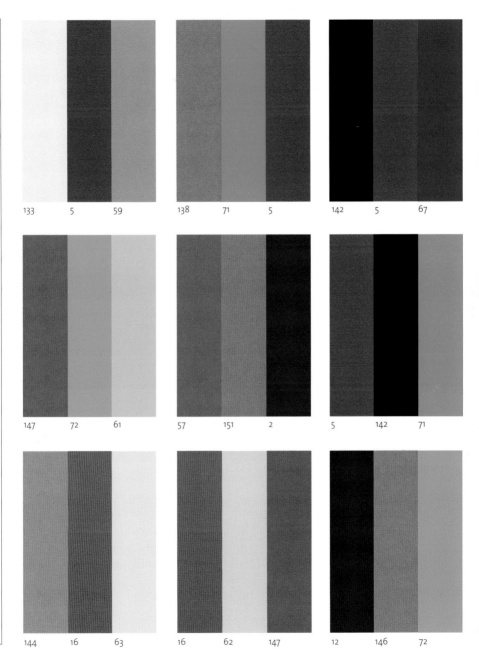

133 5 59

138 71 5

142 5 67

147 72 61

57 151 2

5 142 71

144 16 63

16 62 147

12 146 72

Inspiration

Jewel colors have a profound impact. These bright colors strike us and leave a lasting impression. To use jewels successfully, look for inspiration by observing color in nature, art, interiors, and fashion. By studying color as it is used in nature you will begin to find endless combinations and pairings eliciting the most basic and primitive of human emotions. Nature offers some of the brightest hues imaginable—for example, picture lusciously rich fresh-fruit colors like mango and papaya teamed with yet another fresh-fruit color like purple-toned blueberry. Italian designer Emilio Pucci's signature flamboyant swirling palette of "Pucci blue", magenta, emerald, hot pink and acid orange hues were inspired by his travels and his observations of Mediterranean seascapes.

© Shinichi Esuchi/Photonica

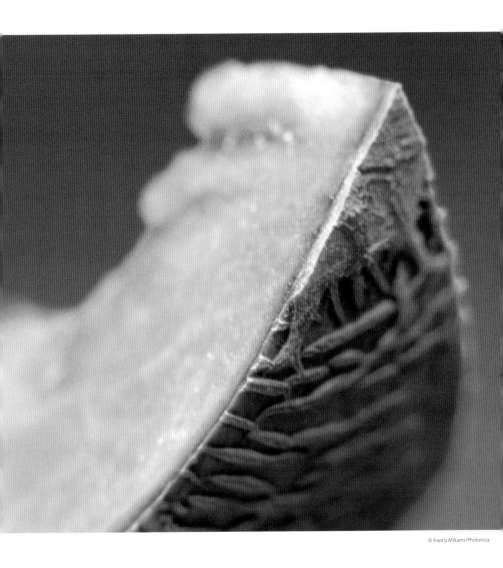

Explore the work of great artists, art movements, and time periods who utilized bright and vivid palettes to garner inspiration. Artists who favored jewels include Van Gogh's use of complementary jewels, to Warhol's intensely colored pop art, to the naive art of Grandma Moses whose folk art often used bright and basic color combinations. Bright saturated dots of color were the basis for the Pointillism movement—the vivid colored dots were intended to create images and colors literally mixed by the eyes of the viewer. Matisse painted spontaneously using graphic, bright colors and patterns in the French style termed "fauvism". Artists, art movements, and time periods provide a wealth of ideas for mixing bright jewel color combinations.

Inspiration for jewel hues can be found throughout cultures and time. Victorian interior designs often used intense jewel hues and vivid colors. Eastern interiors often focus on stunning multi-hued color combinations, blending orange, yellow-orange and true green. Modern high energy palettes balance vintage and historical inspiration with creative vitality and large expanses of pure bright color and pattern. Contemporary interiors and fashions feature fabrics in a wide array of jewels from deeply saturated purples, high intensity pinks, full blues, spicy exotic red and orange hues such as paprika, salsa, tomato and cinnabar to serenely expressive palette's that detail nearly every shade of green.

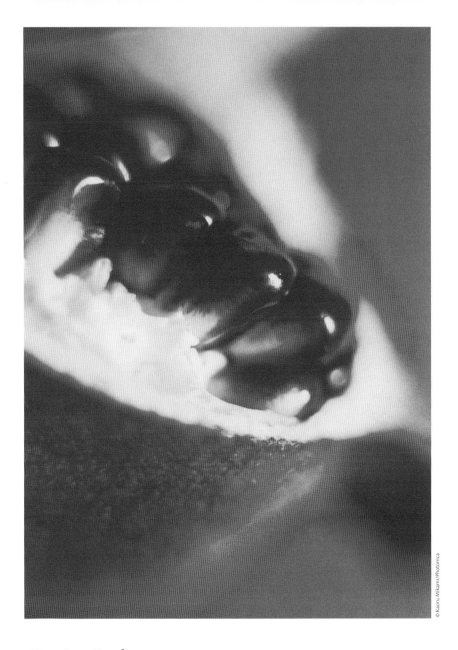

© Kaoru Mikami/Photonica

Your Own Moods

Create your own inspirational mood board or file that focuses on your personal color preferences. Start by collecting fabric swatches, ribbon, magazine, catalog clippings, and paint sample cards that appeal to you. As you progress and your files grow, consider dividing by type of project, season, or color family.

Process Color Conversion Chart

COLOR NO.	CYAN C	MAGENTA M	YELLOW Y	BLACK K		COLOR NO.	CYAN C	MAGENTA M	YELLOW Y	BLACK K
1	0	100	100	60		39	0	30	80	0
2	0	100	100	45		40	0	25	60	0
3	0	100	100	25		41	0	15	40	0
4	0	100	100	15		42	0	10	20	0
5	0	100	100	0		43	0	7	17	0
6	0	85	70	0		44	0	5	15	0
7	0	65	50	0		45	0	0	100	55
8	0	45	30	0		46	0	0	100	45
9	0	20	10	0		47	0	0	100	25
10	0	15	8	0		48	0	0	100	15
11	0	10	4	0		49	0	0	100	0
12	0	90	80	60		50	0	0	80	0
13	0	90	80	45		51	0	0	60	0
14	0	90	80	25		52	0	0	40	0
15	0	90	80	15		53	0	0	25	0
16	0	90	80	0		54	0	0	20	0
17	0	70	65	0		55	0	0	15	0
18	0	55	50	0		56	60	0	100	55
19	0	40	35	0		57	60	0	100	45
20	0	20	20	0		58	60	0	100	25
21	0	15	15	0		59	60	0	100	15
22	0	10	10	0		60	60	0	100	0
23	0	60	100	65		61	50	0	80	0
24	0	60	100	45		62	35	0	60	0
25	0	60	100	25		63	25	0	40	0
26	0	60	100	15		64	12	0	20	0
27	0	60	100	0		65	7	0	15	0
28	0	50	80	0		66	5	0	13	0
29	0	40	60	0		67	100	0	90	55
30	0	25	40	0		68	100	0	90	45
31	0	15	20	0		69	100	0	90	25
32	0	10	15	0		70	100	0	90	15
33	0	7	12	0		71	100	0	90	0
34	0	40	100	55		72	80	0	75	0
35	0	40	100	45		73	60	0	55	0
36	0	40	100	25		74	45	0	35	0
37	0	40	100	15		75	25	0	20	0
38	0	40	100	0		76	20	15	0	0

COLOR NO.	CYAN C	MAGENTA M	YELLOW Y	BLACK K		COLOR NO.	CYAN C	MAGENTA M	YELLOW Y	BLACK K
77	15	10	0	0		96	50	25	0	0
78	100	0	40	55		97	30	15	0	0
79	100	0	40	45		98	25	10	0	0
80	100	0	40	25		99	20	5	0	0
81	100	0	40	15		100	100	90	0	55
82	100	0	40	0		101	100	90	0	45
83	80	0	30	0		102	100	90	0	25
84	60	0	25	0		103	100	90	0	15
85	45	0	20	0		104	100	90	0	0
86	25	0	10	0		105	85	80	0	0
87	20	0	5	0		106	75	65	0	0
88	15	0	3	0		107	60	55	0	0
89	100	60	0	55		108	45	40	0	0
90	100	60	0	45		109	35	30	0	0
91	100	60	0	25		110	30	25	0	0
92	100	60	0	15		111	80	100	0	55
93	100	60	0	0		112	80	100	0	45
94	85	50	0	0		113	80	100	0	25
95	65	40	0	0		114	80	100	0	15

COLOR NO.	CYAN C	MAGENTA M	YELLOW Y	BLACK K
115	80	100	0	0
116	65	85	0	0
117	55	65	0	0
118	40	50	0	0
119	25	30	0	0
120	20	25	0	0
121	15	20	0	0
122	40	100	0	55
123	40	100	0	45
124	40	100	0	25
125	40	100	0	15
126	40	100	0	0
127	35	80	0	0
128	25	60	0	0
129	20	40	0	0
130	10	20	0	0
131	8	15	0	0
132	5	10	0	0
133	0	0	0	10

COLOR NO.	CYAN C	MAGENTA M	YELLOW Y	BLACK K
134	0	0	0	20
135	0	0	0	30
136	0	0	0	35
137	0	0	0	45
138	0	0	0	55
139	0	0	0	65
140	0	0	0	075
141	0	0	0	85
142	0	0	0	100
143	15	10	10	15
144	35	20	20	30
145	3	15	3	35
146	10	20	10	45
147	10	40	10	55
148	5	5	20	5
149	10	10	35	10
150	30	30	55	30
151	35	30	60	30
152	40	40	90	40

3

C	0
M	100
Y	100
K	25

2

C	0
M	100
Y	100
K	45

1

C	0
M	100
Y	100
K	60

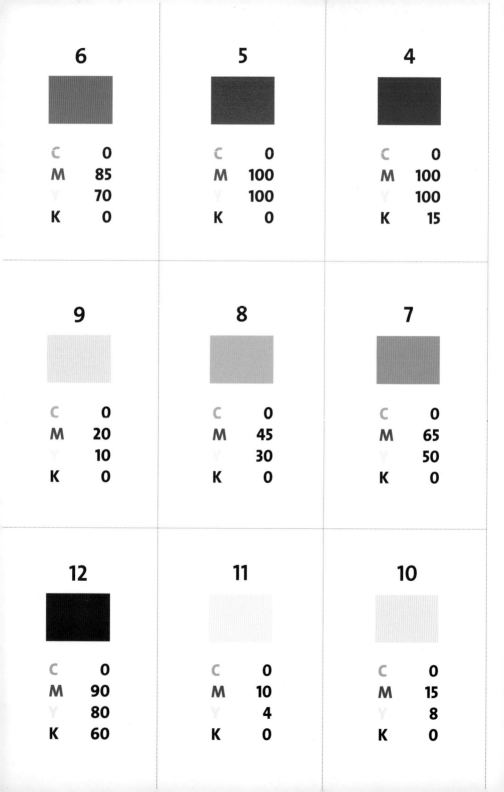

6	5	4
C 0	C 0	C 0
M 85	M 100	M 100
Y 70	Y 100	Y 100
K 0	K 0	K 15

9	8	7
C 0	C 0	C 0
M 20	M 45	M 65
Y 10	Y 30	Y 50
K 0	K 0	K 0

12	11	10
C 0	C 0	C 0
M 90	M 10	M 15
Y 80	Y 4	Y 8
K 60	K 0	K 0

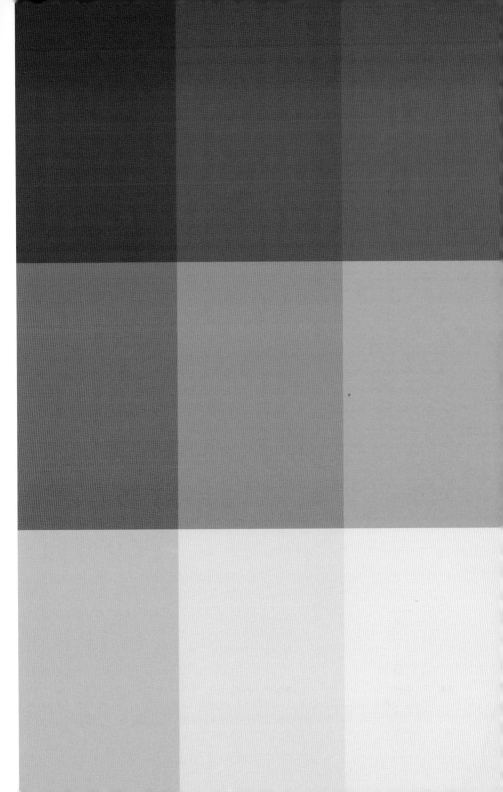

15

C 0
M 90
80
K 15

14

C 0
M 90
80
K 25

13

C 0
M 90
80
K 45

18

C 0
M 55
50
K 0

17

C 0
M 70
65
K 0

16

C 0
M 90
80
K 0

21

C 0
M 15
15
K 0

20

C 0
M 20
20
K 0

19

C 0
M 40
35
K 0

24

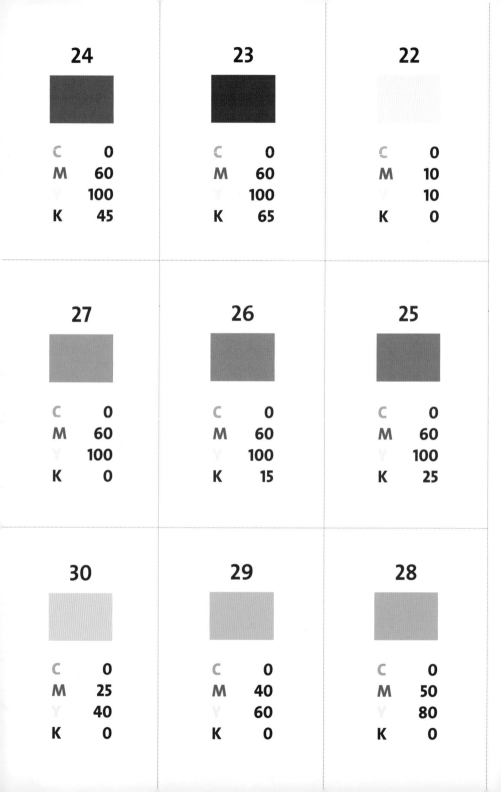

C 0
M 60
Y 100
K 45

23

C 0
M 60
Y 100
K 65

22

C 0
M 10
Y 10
K 0

27

C 0
M 60
Y 100
K 0

26

C 0
M 60
Y 100
K 15

25

C 0
M 60
Y 100
K 25

30

C 0
M 25
Y 40
K 0

29

C 0
M 40
Y 60
K 0

28

C 0
M 50
Y 80
K 0

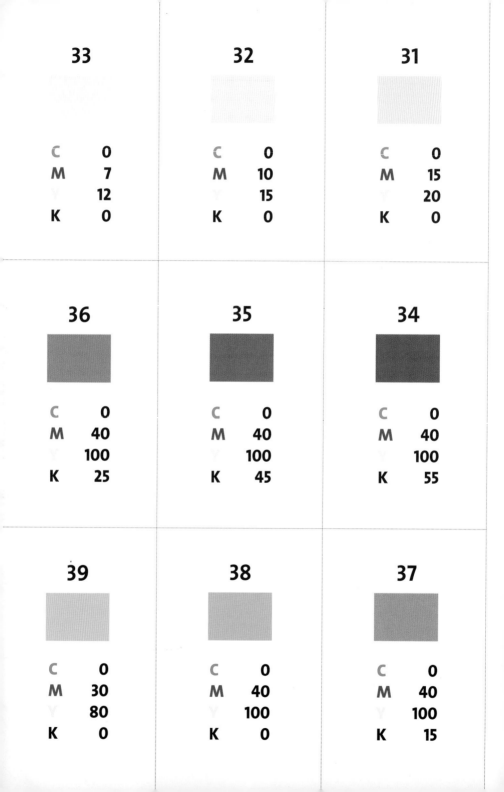

33

C 0
M 7
Y 12
K 0

32

C 0
M 10
Y 15
K 0

31

C 0
M 15
Y 20
K 0

36

C 0
M 40
Y 100
K 25

35

C 0
M 40
Y 100
K 45

34

C 0
M 40
Y 100
K 55

39

C 0
M 30
Y 80
K 0

38

C 0
M 40
Y 100
K 0

37

C 0
M 40
Y 100
K 15

42

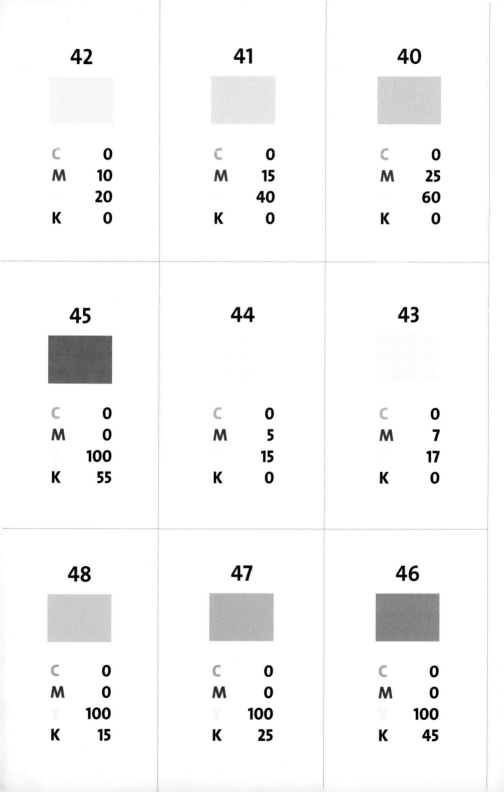

C 0
M 10
20
K 0

41

C 0
M 15
40
K 0

40

C 0
M 25
60
K 0

45

C 0
M 0
100
K 55

44

C 0
M 5
15
K 0

43

C 0
M 7
17
K 0

48

C 0
M 0
100
K 15

47

C 0
M 0
100
K 25

46

C 0
M 0
100
K 45

51

C 0
M 0
Y 60
K 0

50

C 0
M 0
Y 80
K 0

49

C 0
M 0
Y 100
K 0

54

C 0
M 0
Y 20
K 0

53

C 0
M 0
Y 25
K 0

52

C 0
M 0
Y 40
K 0

57

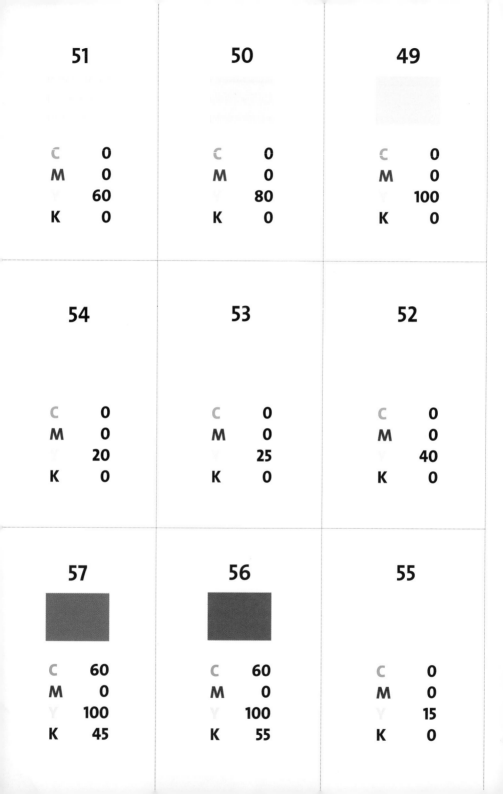

C 60
M 0
Y 100
K 45

56

C 60
M 0
Y 100
K 55

55

C 0
M 0
Y 15
K 0

60

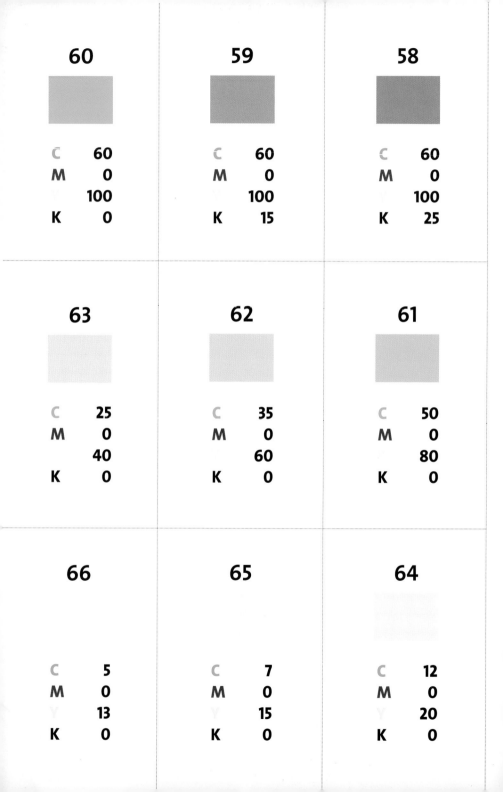

C 60
M 0
100
K 0

59

C 60
M 0
100
K 15

58

C 60
M 0
100
K 25

63

C 25
M 0
40
K 0

62

C 35
M 0
60
K 0

61

C 50
M 0
80
K 0

66

C 5
M 0
13
K 0

65

C 7
M 0
15
K 0

64

C 12
M 0
20
K 0

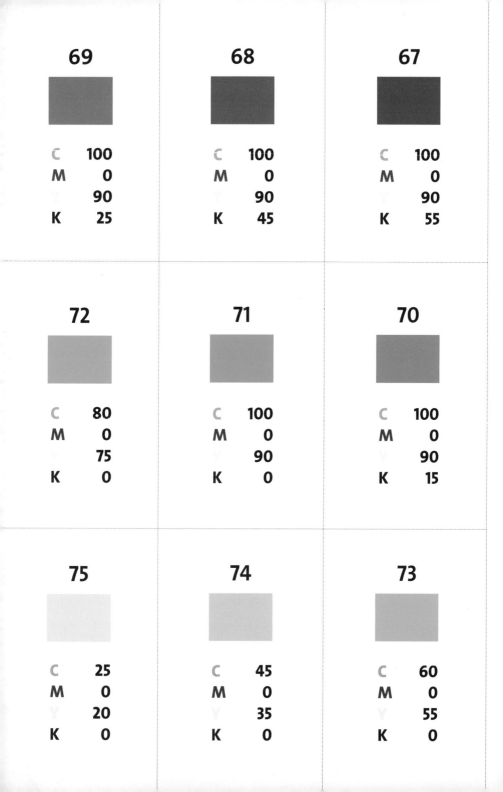

69	68	67
C 100	C 100	C 100
M 0	M 0	M 0
Y 90	Y 90	Y 90
K 25	K 45	K 55

72	71	70
C 80	C 100	C 100
M 0	M 0	M 0
Y 75	Y 90	Y 90
K 0	K 0	K 15

75	74	73
C 25	C 45	C 60
M 0	M 0	M 0
Y 20	Y 35	Y 55
K 0	K 0	K 0

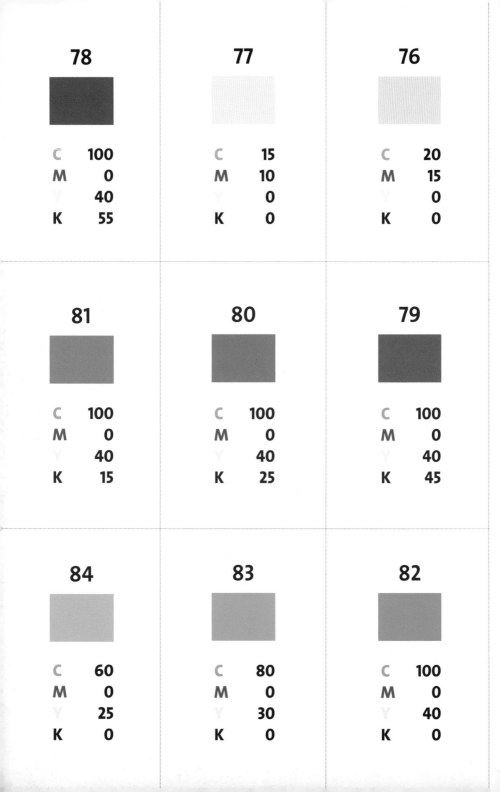

78

C 100
M 0
Y 40
K 55

77

C 15
M 10
Y 0
K 0

76

C 20
M 15
Y 0
K 0

81

C 100
M 0
Y 40
K 15

80

C 100
M 0
Y 40
K 25

79

C 100
M 0
Y 40
K 45

84

C 60
M 0
Y 25
K 0

83

C 80
M 0
Y 30
K 0

82

C 100
M 0
Y 40
K 0

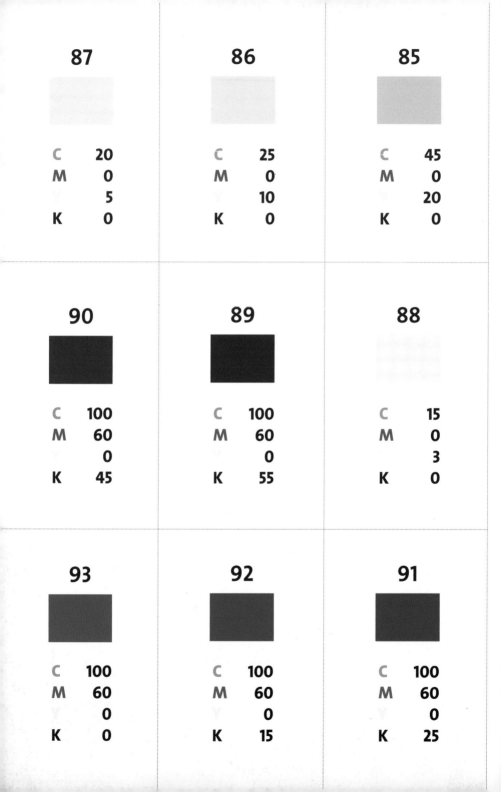

87

C	20
M	0
Y	5
K	0

86

C	25
M	0
Y	10
K	0

85

C	45
M	0
Y	20
K	0

90

C	100
M	60
Y	0
K	45

89

C	100
M	60
Y	0
K	55

88

C	15
M	0
Y	3
K	0

93

C	100
M	60
Y	0
K	0

92

C	100
M	60
Y	0
K	15

91

C	100
M	60
Y	0
K	25

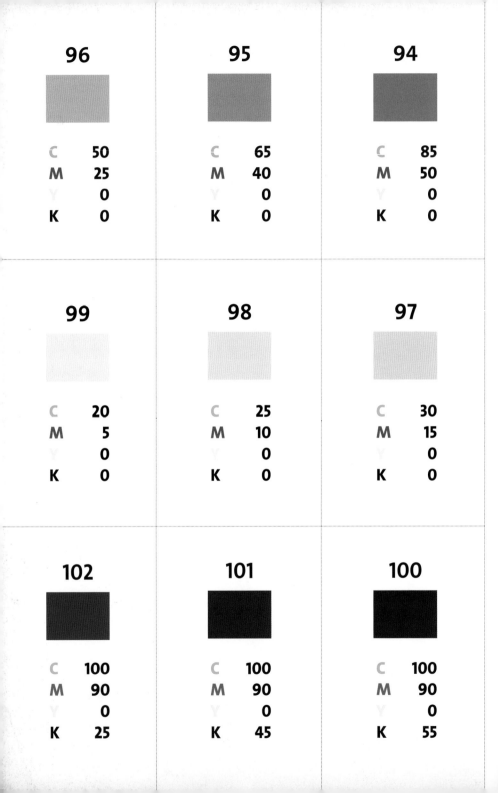

96

C 50
M 25
Y 0
K 0

95

C 65
M 40
Y 0
K 0

94

C 85
M 50
Y 0
K 0

99

C 20
M 5
Y 0
K 0

98

C 25
M 10
Y 0
K 0

97

C 30
M 15
Y 0
K 0

102

C 100
M 90
Y 0
K 25

101

C 100
M 90
Y 0
K 45

100

C 100
M 90
Y 0
K 55

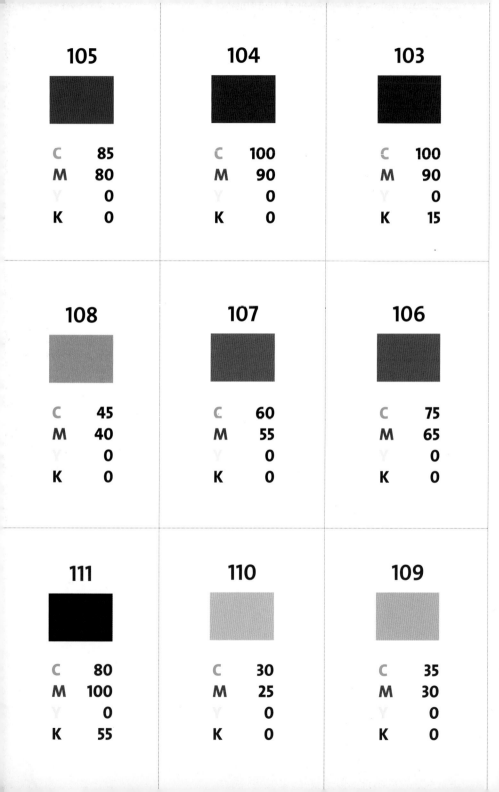

105

C	85
M	80
Y	0
K	0

104

C	100
M	90
Y	0
K	0

103

C	100
M	90
Y	0
K	15

108

C	45
M	40
Y	0
K	0

107

C	60
M	55
Y	0
K	0

106

C	75
M	65
Y	0
K	0

111

C	80
M	100
Y	0
K	55

110

C	30
M	25
Y	0
K	0

109

C	35
M	30
Y	0
K	0

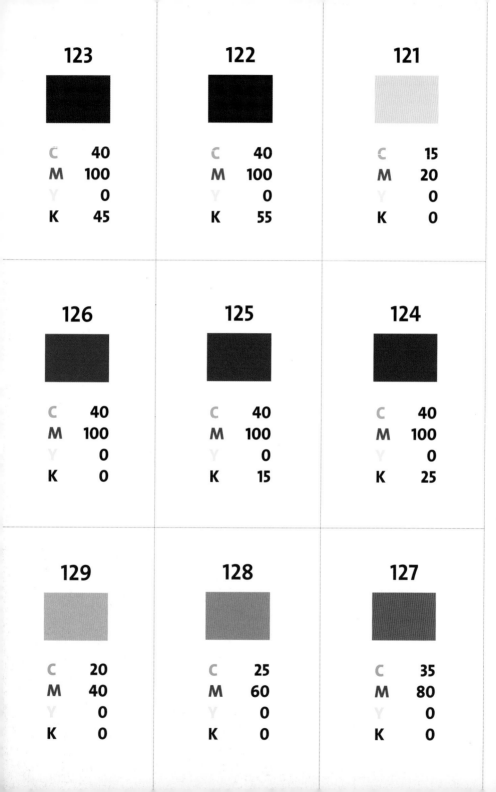

123

C	40
M	100
Y	0
K	45

122

C	40
M	100
Y	0
K	55

121

C	15
M	20
Y	0
K	0

126

C	40
M	100
Y	0
K	0

125

C	40
M	100
Y	0
K	15

124

C	40
M	100
Y	0
K	25

129

C	20
M	40
Y	0
K	0

128

C	25
M	60
Y	0
K	0

127

C	35
M	80
Y	0
K	0

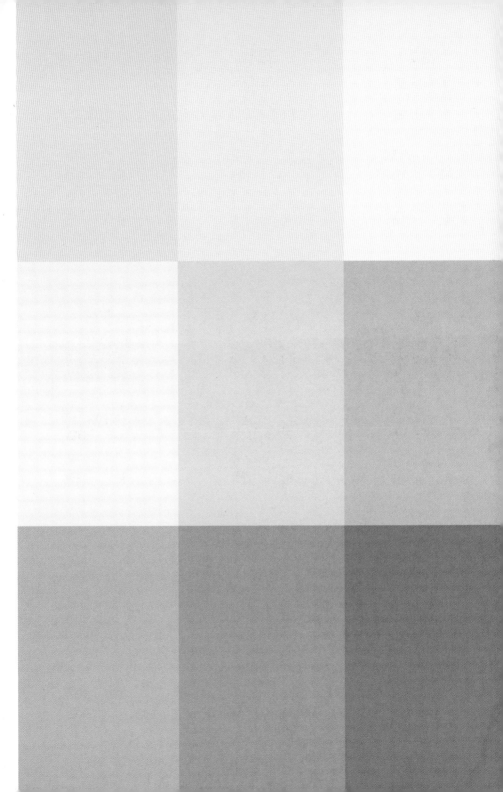

132

C 5
M 10
Y 0
K 0

131

C 8
M 15
Y 0
K 0

130

C 10
M 20
Y 0
K 0

135

C 0
M 0
Y 0
K 30

134

C 0
M 0
Y 0
K 20

133

C 0
M 0
Y 0
K 10

138

C 0
M 0
Y 0
K 55

137

C 0
M 0
Y 0
K 45

136

C 0
M 0
Y 0
K 35

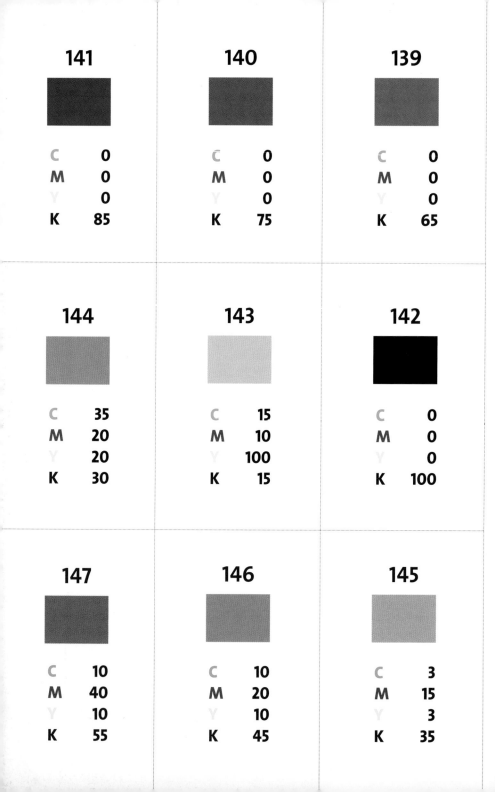

141
C 0
M 0
Y 0
K 85

140
C 0
M 0
Y 0
K 75

139
C 0
M 0
Y 0
K 65

144
C 35
M 20
Y 20
K 30

143
C 15
M 10
Y 100
K 15

142
C 0
M 0
Y 0
K 100

147
C 10
M 40
Y 10
K 55

146
C 10
M 20
Y 10
K 45

145
C 3
M 15
Y 3
K 35

149

C	10
M	10
Y	30
K	10

148

C	5
M	5
Y	20
K	5

151

C	35
M	30
Y	60
K	30

150

C	30
M	30
Y	55
K	30

152

C	40
M	40
Y	90
K	40

About the Author

Martha Gill is a freelance graphic designer, spokesperson and entrepreneur. She is the author and designer of the *Modern Lifestyle Guides* a book series created for people with more style than time. Martha has received national recognition with features in the *Chicago Tribune*, *New York Daily News*, *LA Times*, *InStyle* and on *E!'s Style Network*. She lives with her husband and two children in Atlanta, Georgia.